Big THANK YOU for supporting my cozy little art hub with your purchase!

These nifty books and images are like magical stencils for your watercolor adventures, letting you mix and match to your heart's content. Beginner or seasoned pro, this method is your ticket to a world of artistic exploration. Pick your faves, trace them onto watercolor paper, and let your creativity run wild with those paints. It's not just about honing your skills; it's about unlocking a universe of personalized masterpieces. Also, if you enjoy this book, please consider giving me a review on Amazon. It helps tremendously! Thank you!

Happy creating!

Jessie

Ways to Transfer the Images to Watercolour Paper:

1. Light Box
Place your watercolour paper on a light box with the image beneath it. The light will help you see through the paper, making it super easy to trace.

2. Tracing Paper
Lay a sheet of tracing paper over the image, trace the image, then place the tracing paper on the watercolour paper and trace the lines again to transfer the drawing.

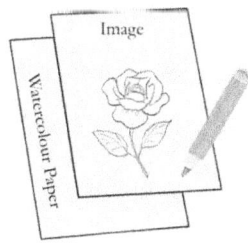

3. Graphite Transfer
Shade the back of the image with a graphite pencil, the place it graphite-side down onto the watercolour paper. trace the image to transfer the graphite onto the paper.

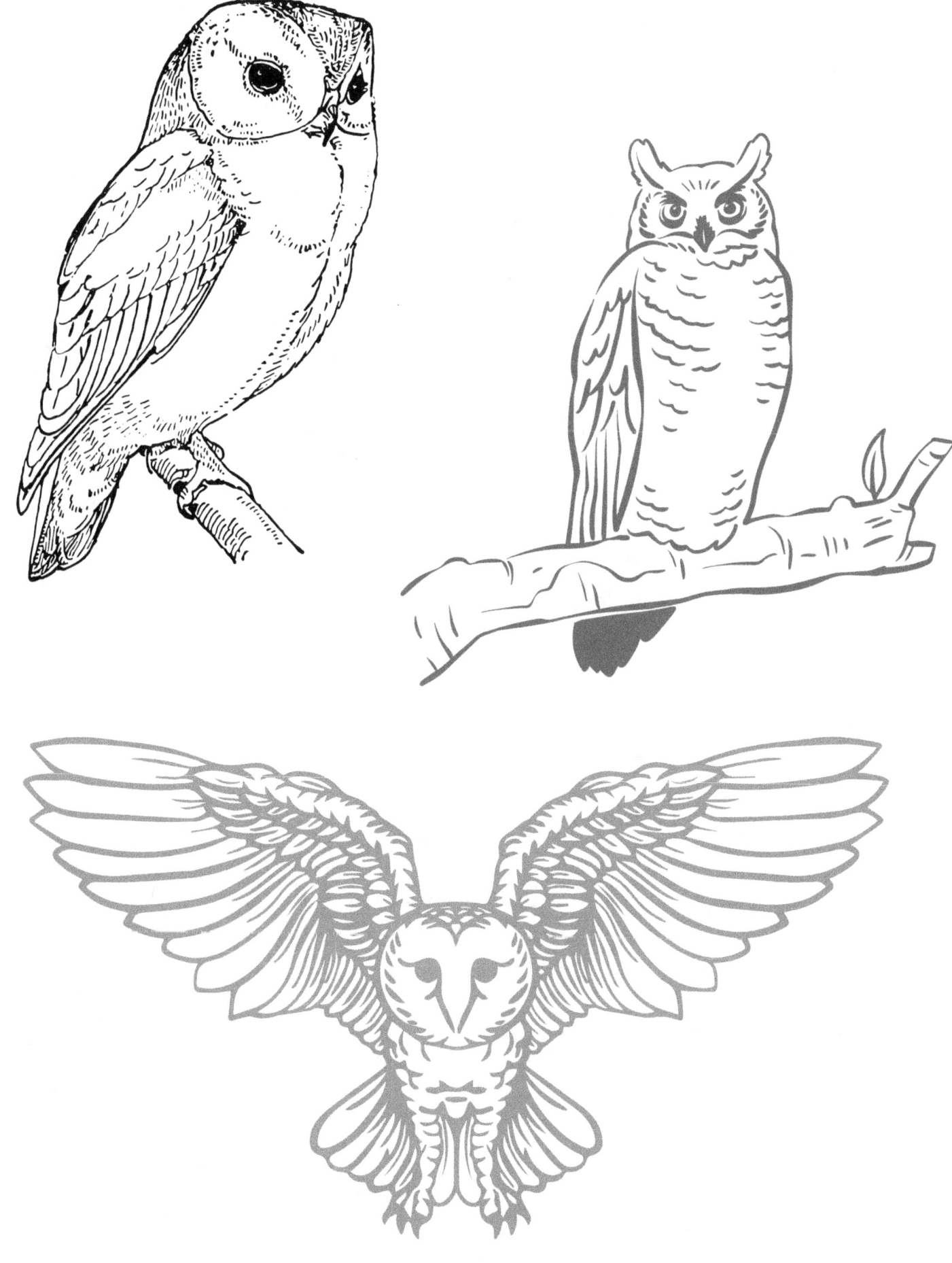

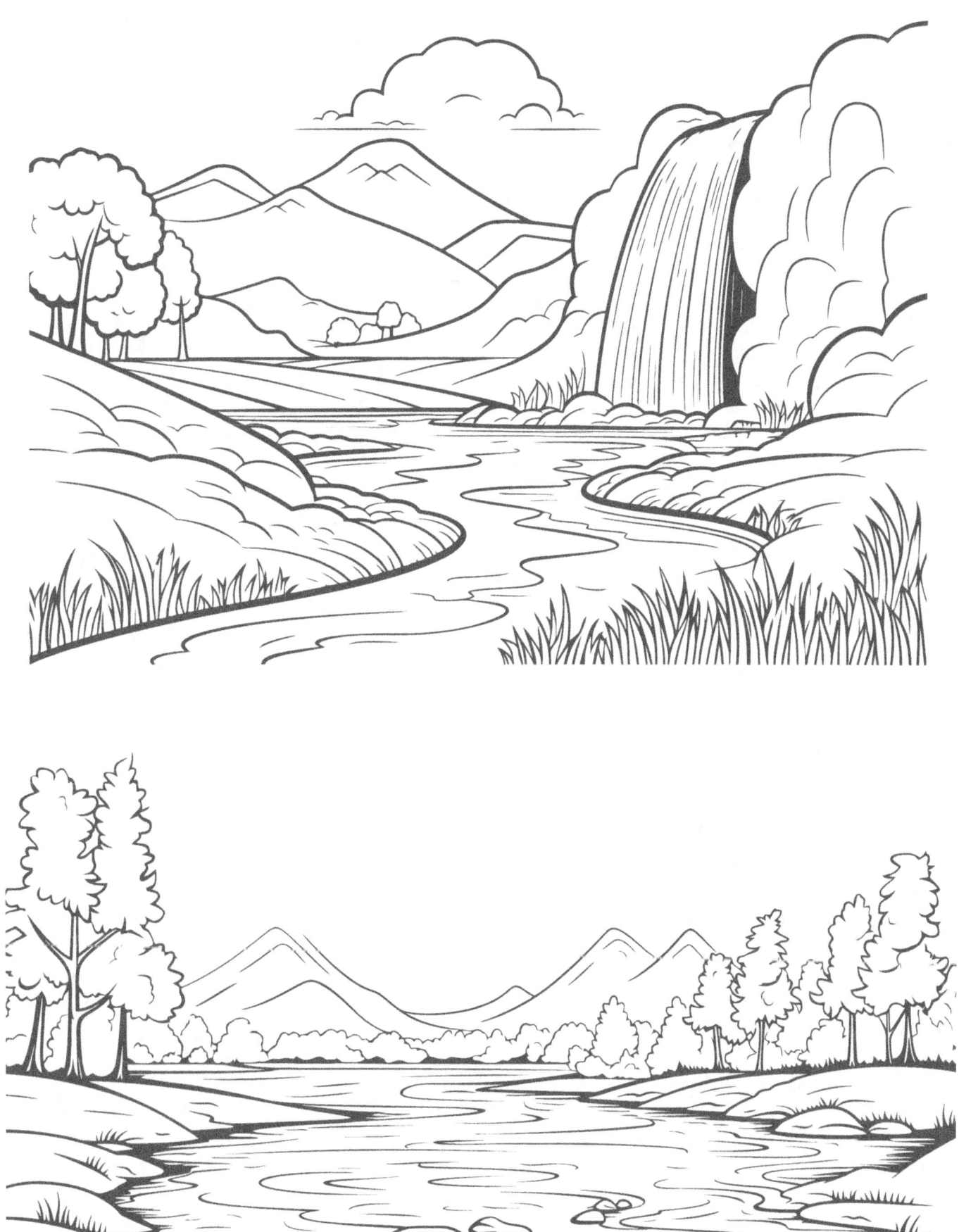

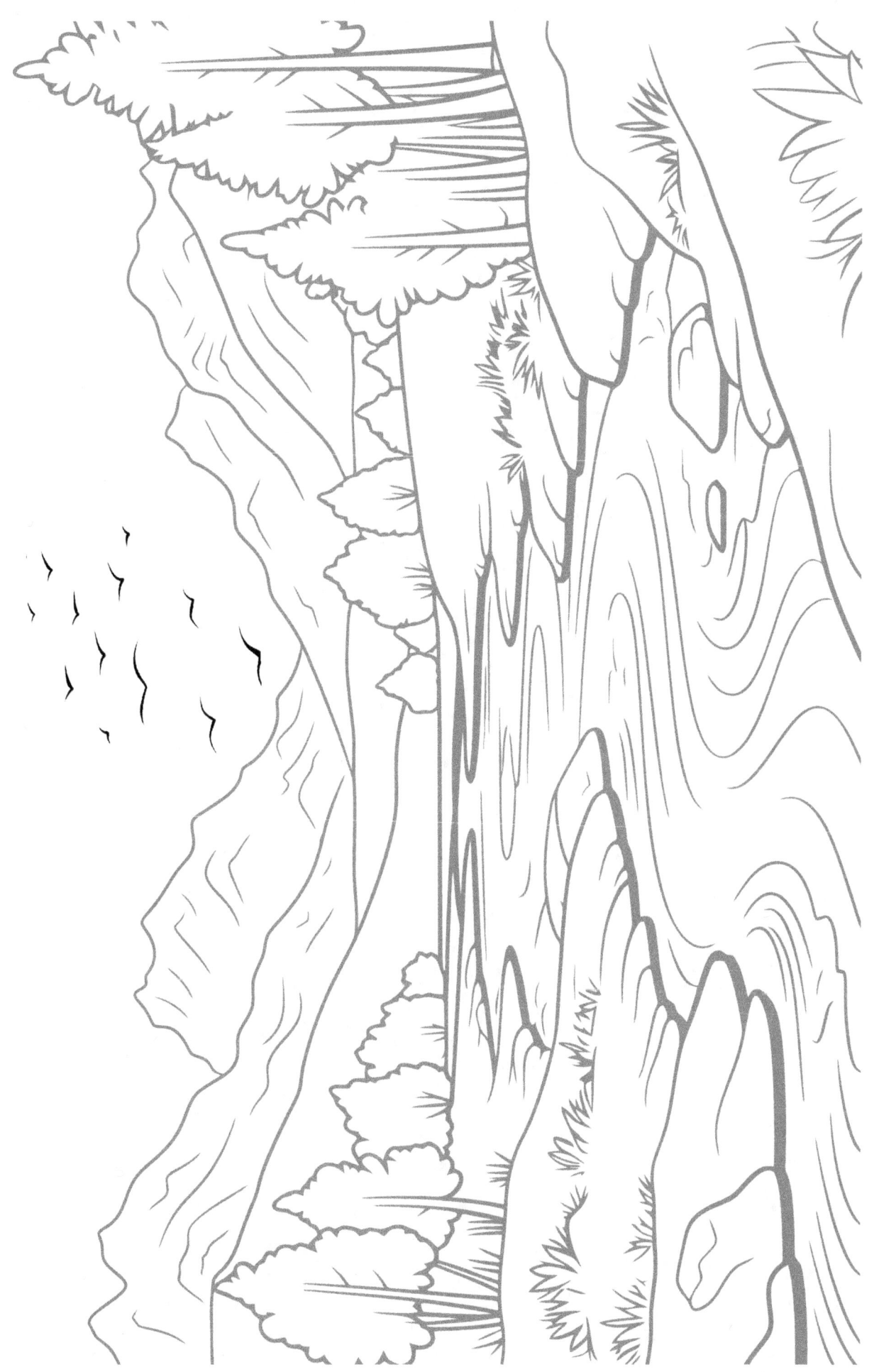

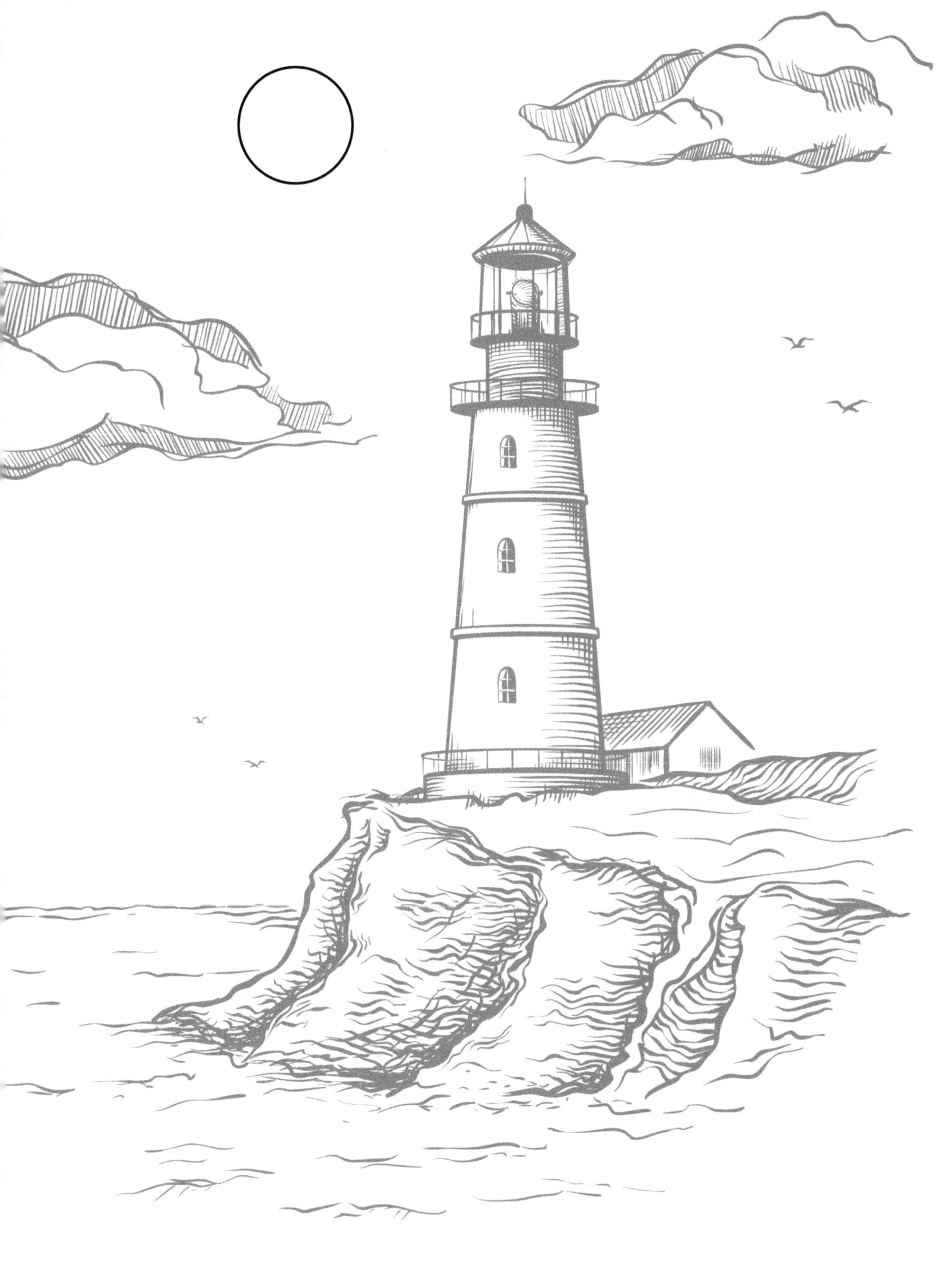

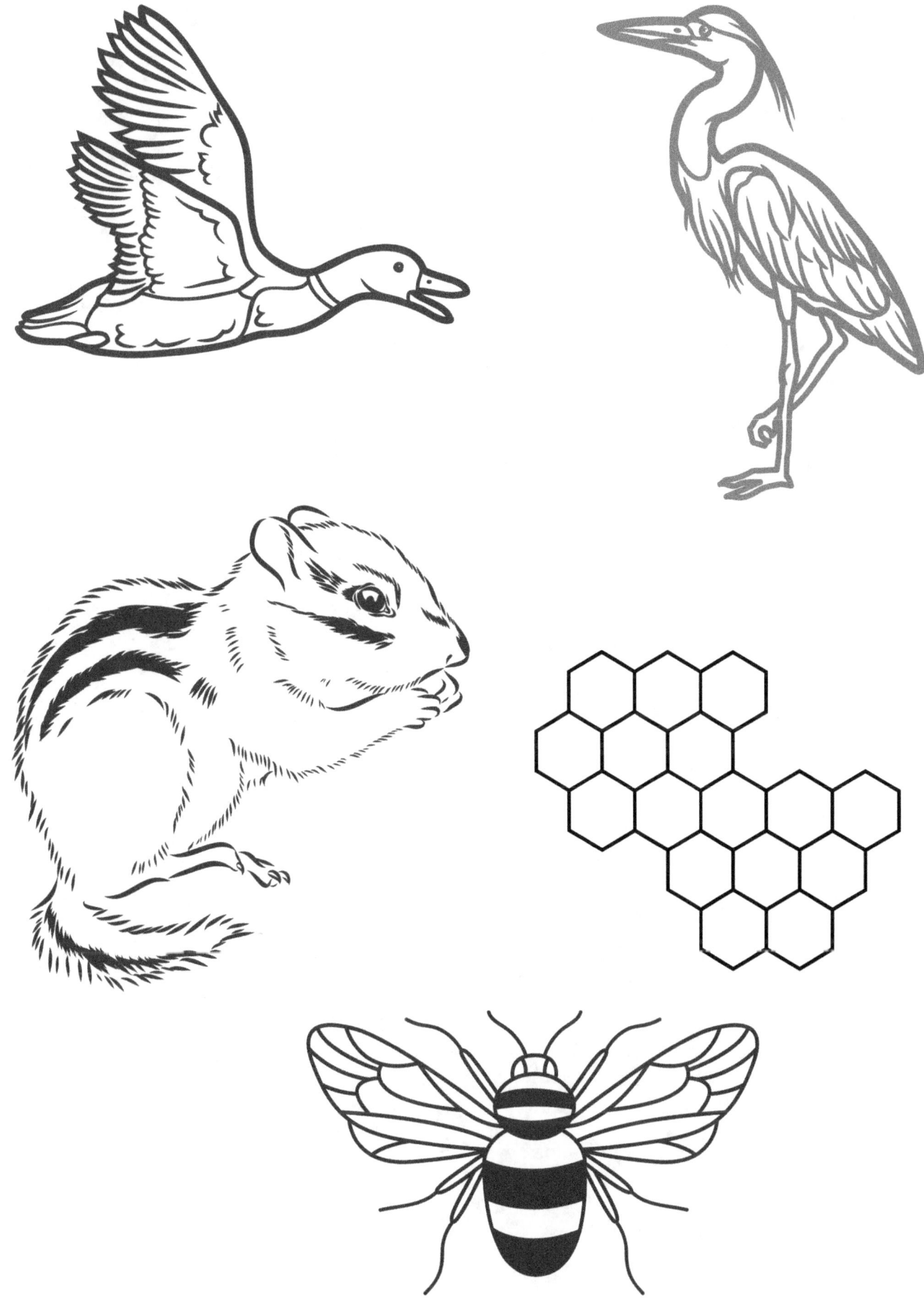

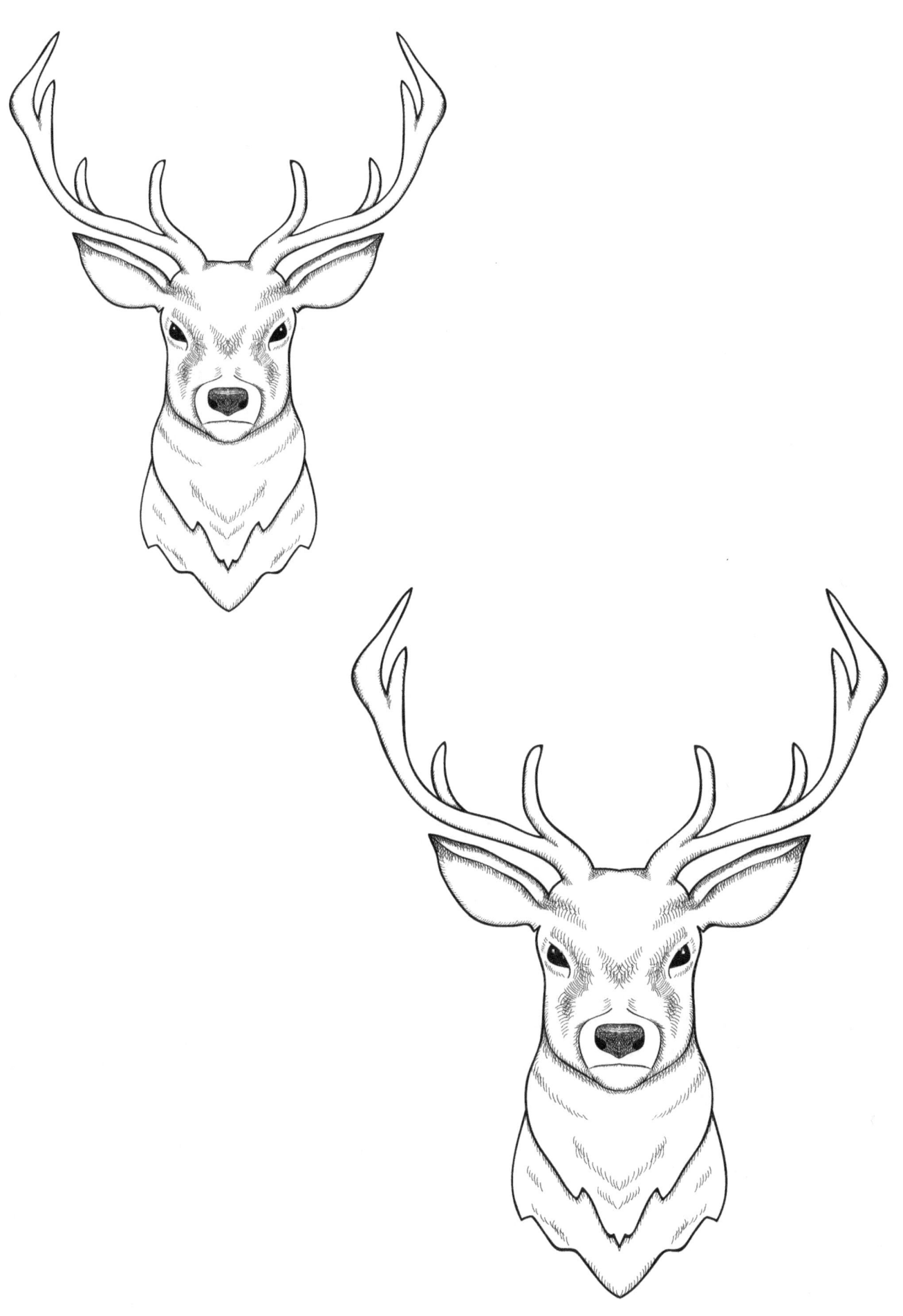

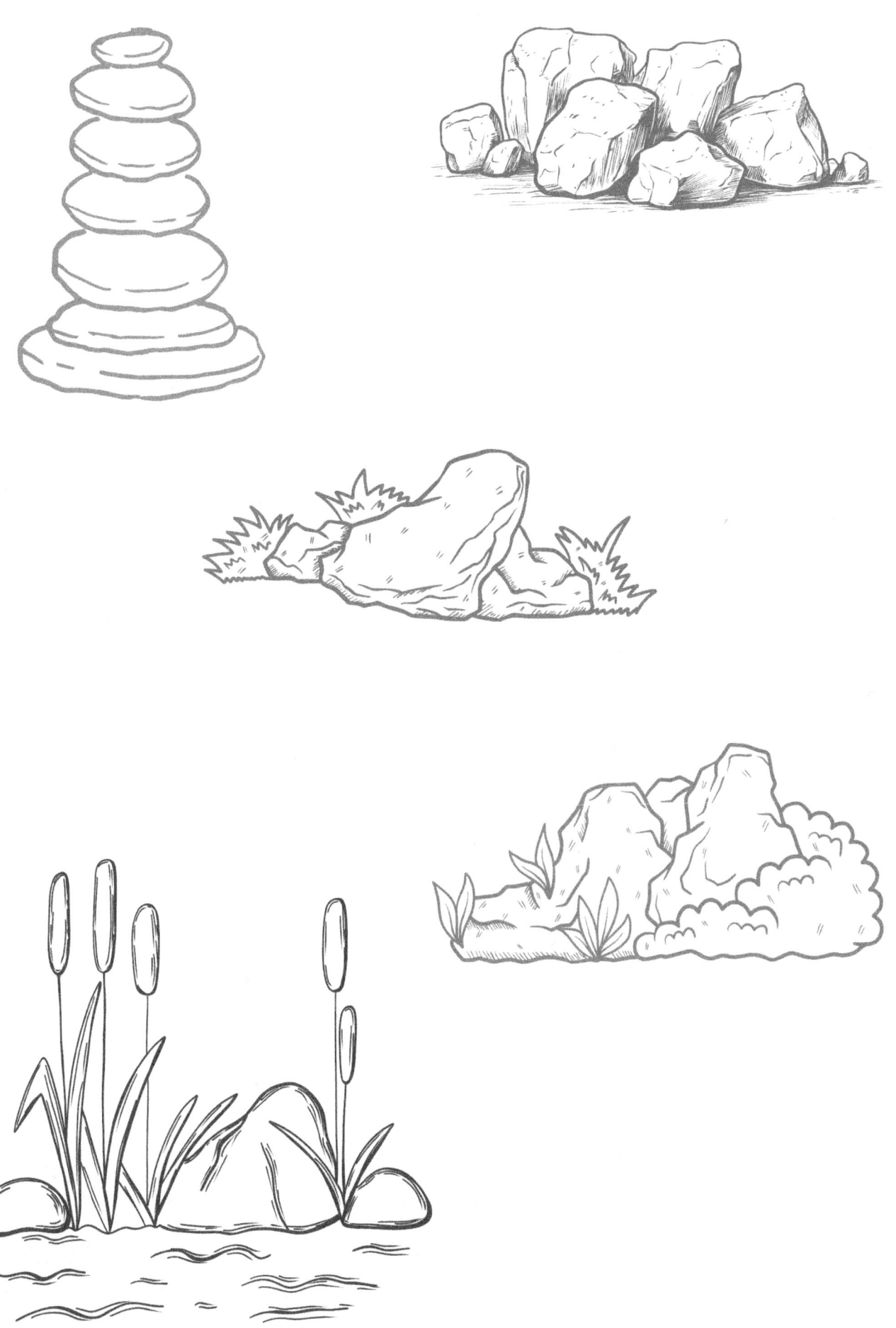

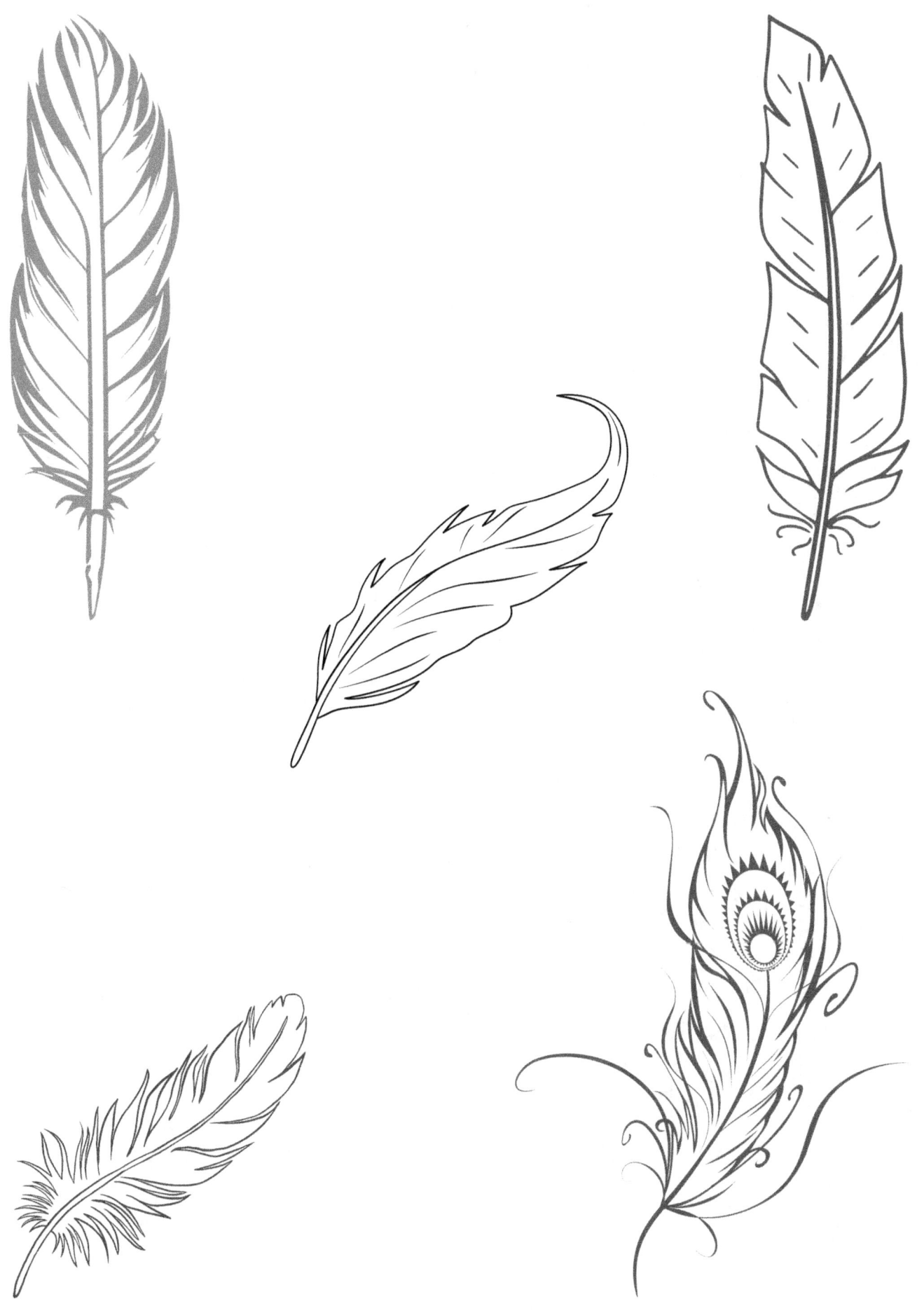

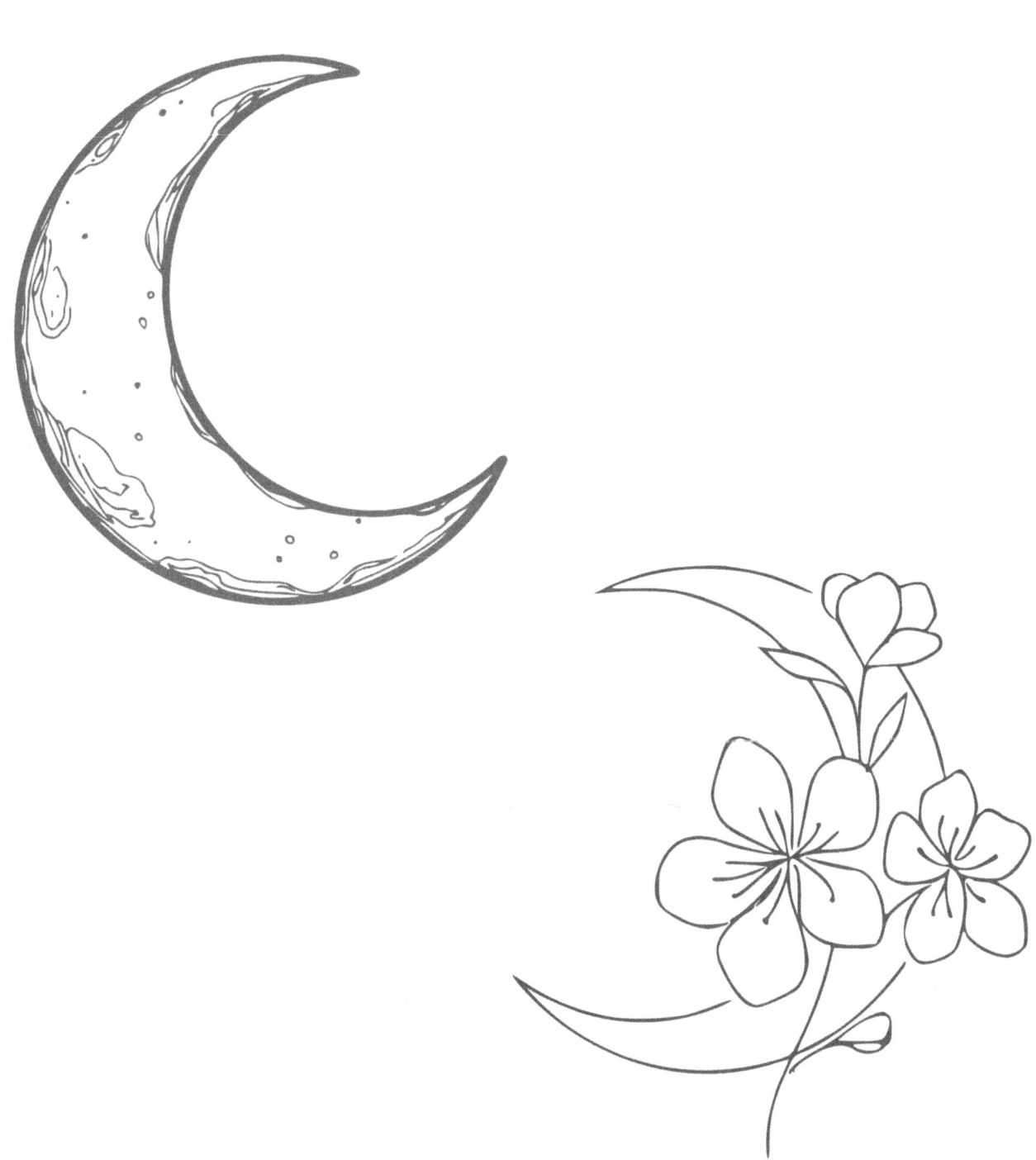

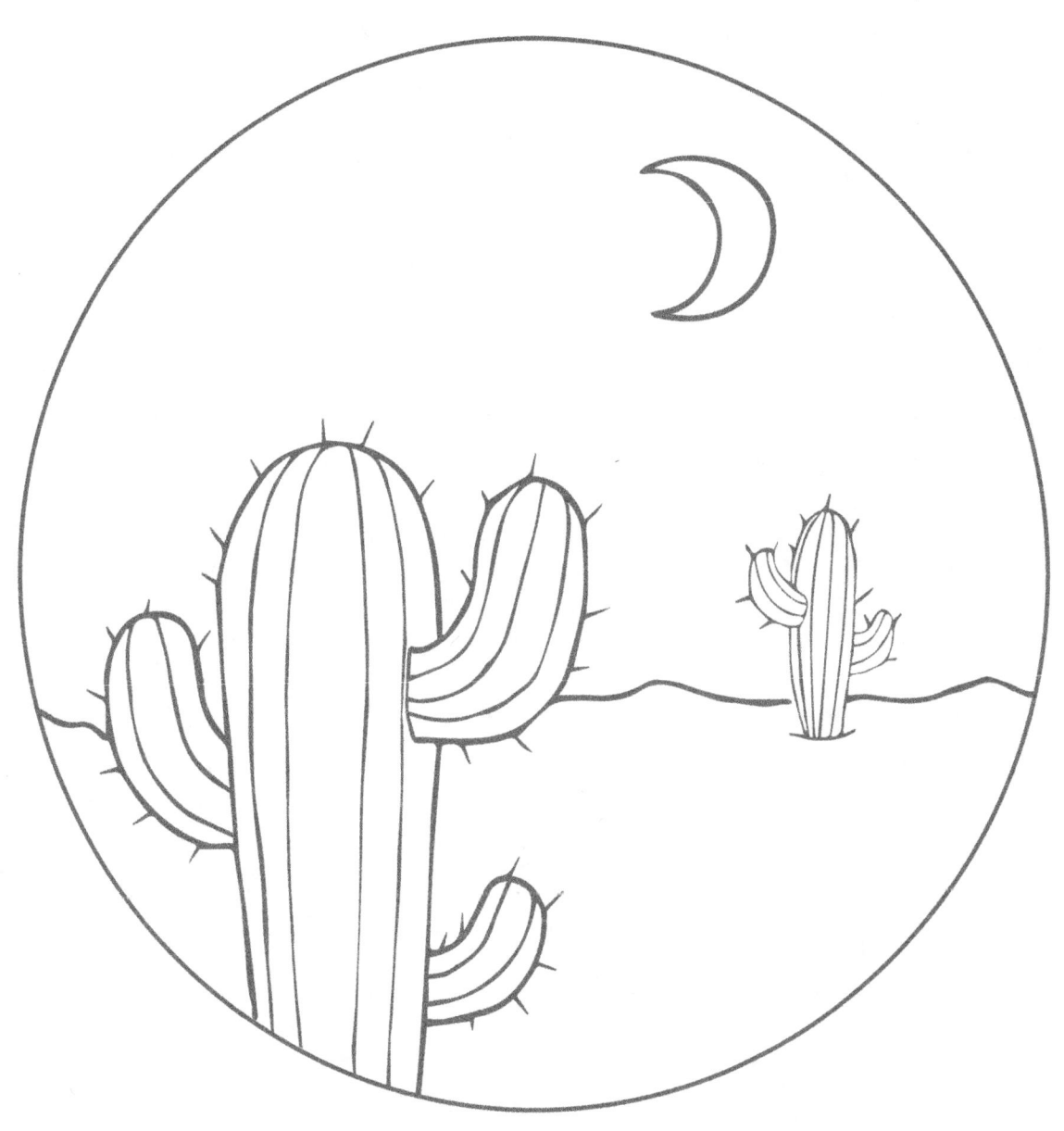

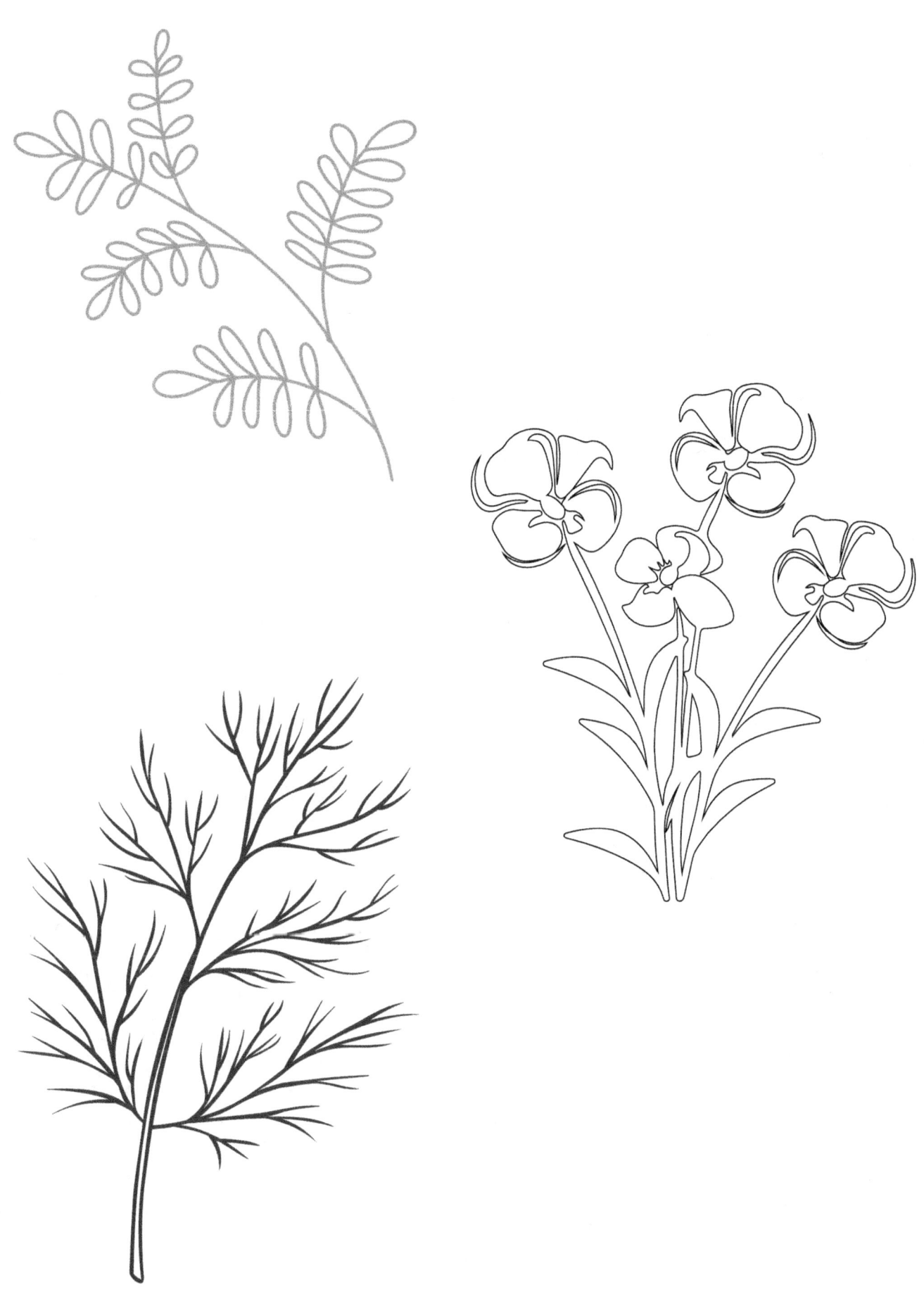

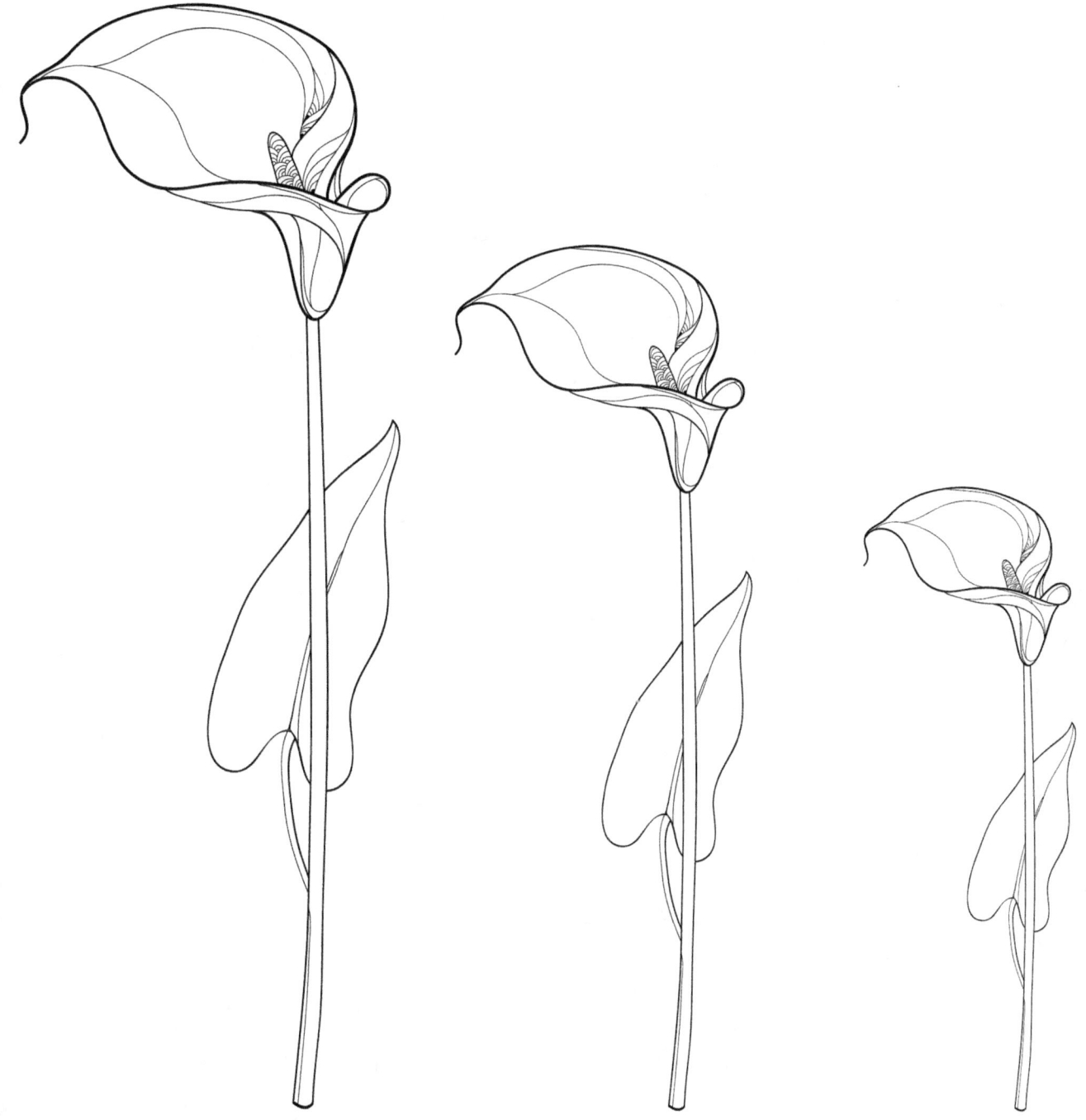

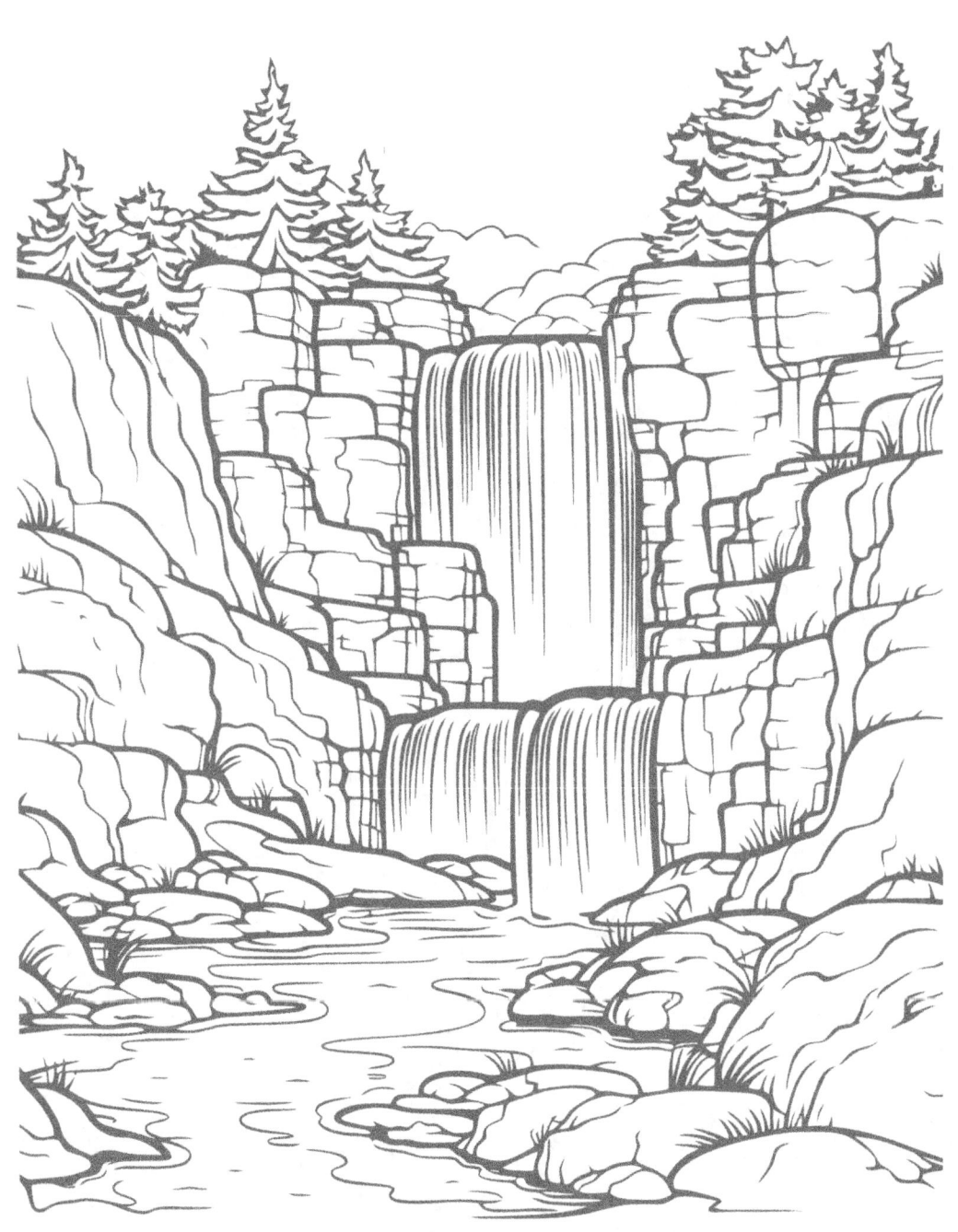

www.ingramcontent.com/pod-product-compliance
Lightning Source LLC
Chambersburg PA
CBHW082236220526
45479CB00005B/1255